Dispatcher

COLORING BOOK

A FUNNY SARCASTIC ADULT COLORING BOOK

Copyright © 2022 Marikz Publishing

All rights reserved. No part of this book my be used or reproduced in any manner whatsoever without written permission except in the case of brief quotations embodied in critical articles and reviews.

THIS BOOK BELONGS TO:

COLOR TEST PAGE

World's Okayest Dispatcher

SHUT UP AND SAY 10-4

I TELL COPS WHERE TO GO

I NEVER DREAMED I'D BECOME A *dispatcher* BUT HERE I AM KILLING IT

Eat Sleep Dispatch Repeat

911 DISPATCHER AKA MIRACLE WORKER

SOME HEROES WEAR HEADSETS

THIS JOB IS NOT FOR THE WEAK

Stop Calling 911 For Stupid Shit

IF YOU'RE NOT DATING A DISPATCHER RAISE YOUR STANDARDS

BECAUSE I'M THE DISPATCHER THAT'S WHY

DISPATCHER: A PERSON WHO HANDLES EMERGENCIES YOU CAN'T

Your life is worth my time

Your Worst Day Is My Everyday

some Dispatchers cuss too much it's me I'm some Dispatchers

I'm a DISPATCHER nothing scares me.

Proud Dispatcher

I HAVE THE BEST JOB IN THE WORLD

Tell me your Worst and I'll send you The Best

I CAN'T FIX STUPID BUT I CAN FIX WHAT STUPID DOES

Dispatcher
BECAUSE BADASS ISN'T AN OFFICIAL JOB TITLE

THE CALM VOICE IN THE CHAOS

NO ONE FIGHTS ALONE

Don't Make Me Use My Dispatcher Voice

WORLD'S SEXIEST 911 OPERATOR

DISPATCHER ONE OF THE MOST IMPORTANT PEOPLE YOU'LL NEVER SEE

That's what I do I dispatch and I know things

Best Dispatcher Ever